9|83

Half-Life

Photograph by Dennis Purcell

Half-Life

Photographs
by
Rosamond Wolff Purcell

David R. Godine, Publisher, Boston

First published in 1980 by

David R. Godine, Publisher, Inc.
306 Dartmouth Street, Boston, Massachusetts 02116

Some of the material in the Preface first appeared in Print Letter 16, *July/August 1978, Zurich, Switzerland.*

ISBN 0-87923-318-4 LC 79-90553

Printed in the United States of America

to Mary Andrews Wolff and Beth Busser Purcell with love

HALF-LIFE: a. The time required by living tissue, an organ, or an organism to eliminate by biological processes half the quantity of a substance taken in. Also called 'biological half-life.' b. The time required for the radioactivity of material taken in by a living organism to be reduced to half its initial value by a combination of biological elimination processes and radioactive decay. Also called 'effective half-life.'

— The American Heritage Dictionary

Preface

In a shop window, details from the opposite side of the street are often as clear as the objects on display. In a museum, the paintings or creatures behind glass merge with the visitor's reflection. Object and reflection can, with some adjustment of angle, become a single impression.

Many of the beings in these photographs belong to states of mind rather than to reality. The term 'half-life' refers, in many cases, to hybrid or interrupted identity.

Photographically speaking, half-life can refer to anything not fully recorded. It implies a glancing-off of subject matter rather than an embracing of it, something seen out of the corner of the eye rather than trapped in all its relentless detail by the film or by the mind. For me, every object has a potential 'whole life' which, of necessity, must be diminished in order to reemerge as an allusion to ideas rather than as merely a glorified version of itself.

The titles of each section are versions of half-life.

'Cabin Fever' is a term for stir-crazy, housebound folk during bad weather. It might also be an expression for a time when images are permitted to ferment and grow. Writers and composers sometimes seek grants to be locked in cabins, away from worldly pressures. Time given to work from the imagination is a luxury.

'The Exquisite Corpse' (le cadavre exquis of the French surrealists) is a game in which the first player draws a head, the second, without looking at the head, a torso, the third the legs, the fourth the feet. Bones, flesh, hands, feet play against each other.

Many of the photographs in 'Crossing Over' contain 'genetic material' which is expressed differently in other sections of the book. Appearances are

not immutable. Faces shift and change according to the forces of camouflage, coercion, and the passage of time.

Rapid movement of the eyes behind the lids indicates to an observer that the sleeping subject is dreaming. 'R.E.M.' is a signal, but the content of the dream remains unknown unless revealed by the dreamer. Although the photographs in this section, and, for that matter, in every other section, do not refer to my private dreams, they depend occasionally on memories and impressions which I intend to be of general as well as of personal value.

Prints meant to convey ideas should have a transparent quality. They should be free of technical flaws so as not to excite criticism, and they should support, rather than create, possible 'meanings' for an image. Technique more loving than content never fails to impress; it appeals directly. But the visual part of a photograph is just the beginning for me; its potential for creating various levels of meaning is far more significant.

I have seen hats made from whole birds. I look forward to examining frescoes from Pompeii as well as the daily catch at the fish store. Mundane, decadent, and instructive presentations fascinate me equally. Actual physical surfaces (with the exception of the last photograph in this book) function only as allusions. Often the memory of an atmosphere will contribute to the photographs I actually take. I have had a great many visual experiences and have made relatively few photographs.

I do not keep close track of what is being said about photographic styles, but I already know too much to work in a naïve fashion. Although the technical training I have received has proved invaluable, I am glad I never spent much time in formal study of the medium. I would certainly remember what had been said rather than how to see. Finding the thin edge again and again on one's own — that is what is hard to do.

R. W. P.

Technical Note

Of the photographs in this book, three were made on conventional roll film. The rest were made using either a 4 x 5 lightweight folding view camera or an 8 x 10 copy camera on one or another of seven varieties of Polaroid Land film: 3¼ x 4¼ (type 107), 4 x 5 (types 51, 52, and 58), 8 x 10 (type 808), SX-70, and positive-negative (type 105).

Despite the impressive sounding number of choices, I found that I needed to expand the vocabulary of the films beyond the conventions of the instruction sheet. Among the variations are a color photograph of the interference colors in a black and white print (20) and photographs of the 'negative' associated with Polaroid Land sheet films (16, 17, 18).

When using instant materials, I work from print to print rather than more subliminally with negatives which cannot be examined as the photographic event proceeds. My eyes and emotions select; the camera and the prints tell me how much of an illusion will be possible. Although the images occasionally run ahead of consciously applied intelligence, the process is not mysterious. Each print presents itself as an established fact which I must accept, reject, or modify. The method does not allow for wishful thinking.

Contrary to appearance, there is only one double exposure in this collection (32). In other photographs the layered effect was achieved by using a reflective surface to cast light on the subject (25, 37) or a translucent surface through which a background may be seen.

I found many useful faces among nineteenth-century ambrotypes. That these portraits belong to another era is incidental; that they are on glass is all-important.

THE CHAMELEON

He has a froggy head, and a back like a new grave — for shape; and hands like a bird's toes that have been frost-bitten. But his eyes are his exhibition feature. A couple of skinny cones project from the sides of his head, with a wee shiny bead of an eye set in the apex of each; and these cones turn bodily like pivot-guns and point every which way, and they are independent of each other; each has its own exclusive machinery…if something happens above and below him he shoots out one eye upward like a telescope and the other downward — and this changes his expression, but does not improve it.

— *Mark Twain,* Following the Equator, *1897*

Cabin Fever

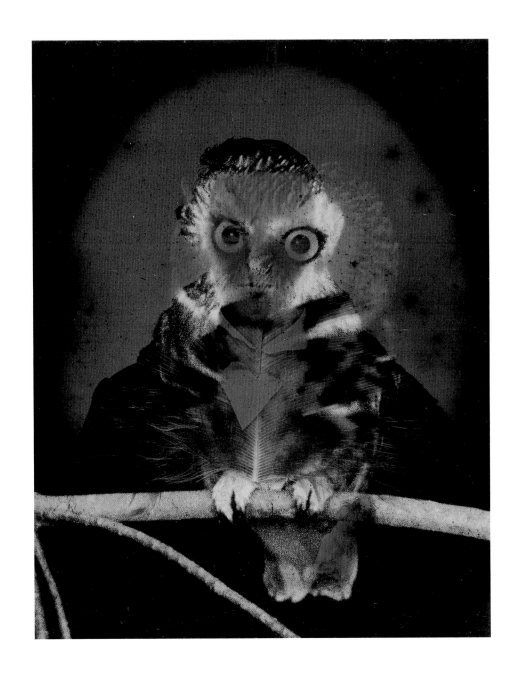

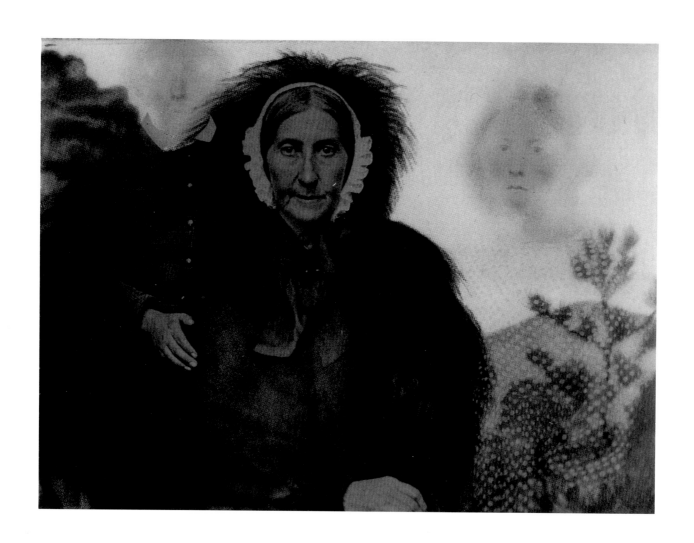

2 · *Grandmama*

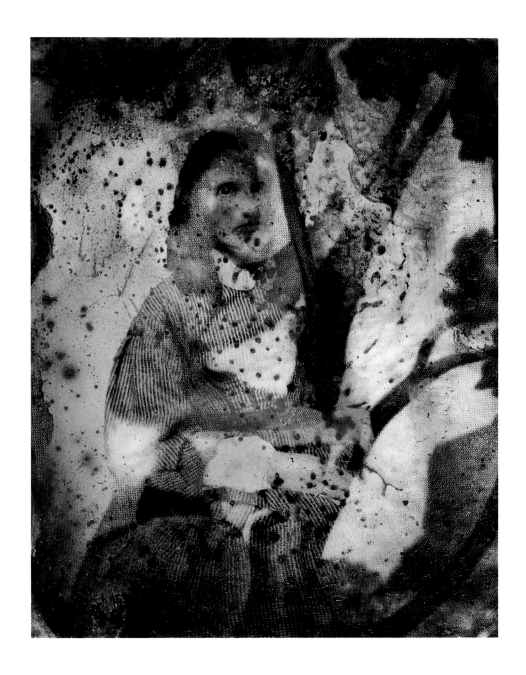

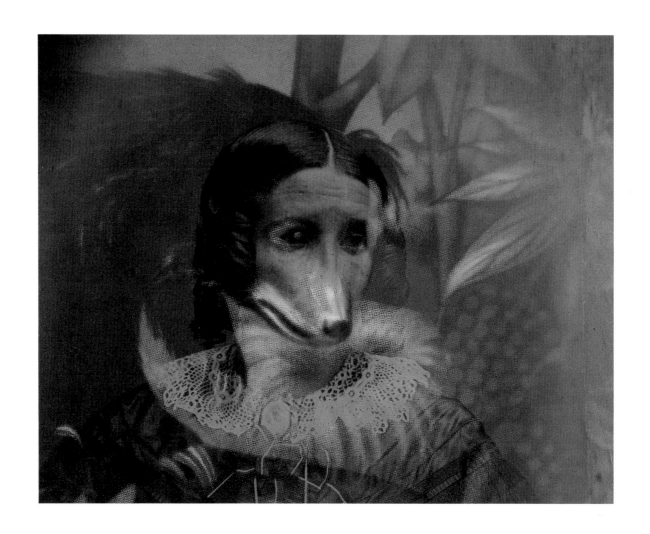

4 • *Ursula*

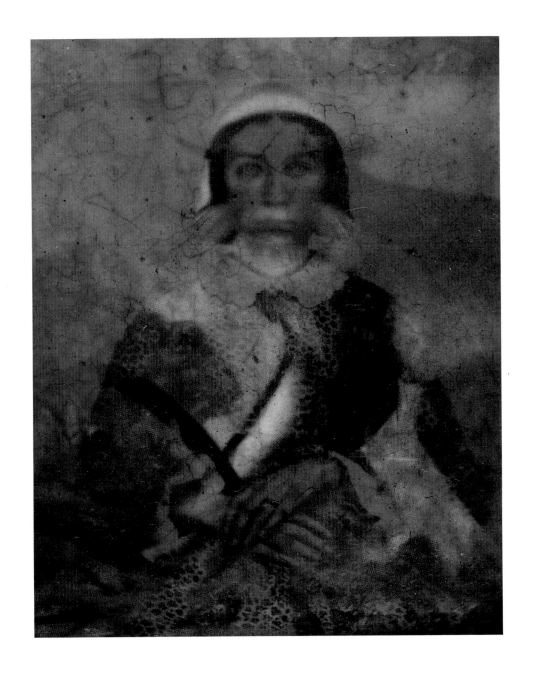

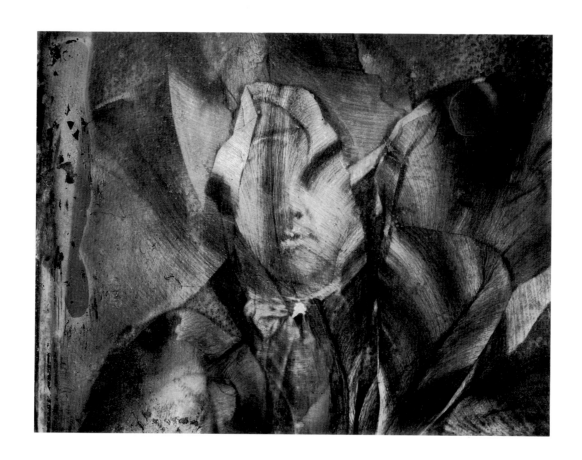

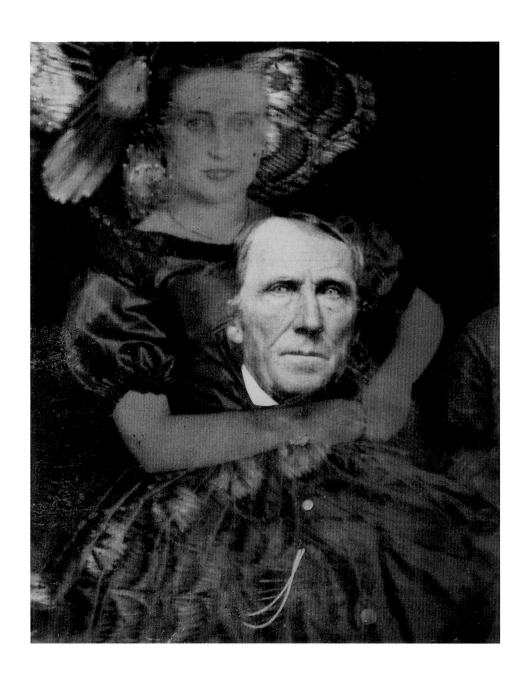

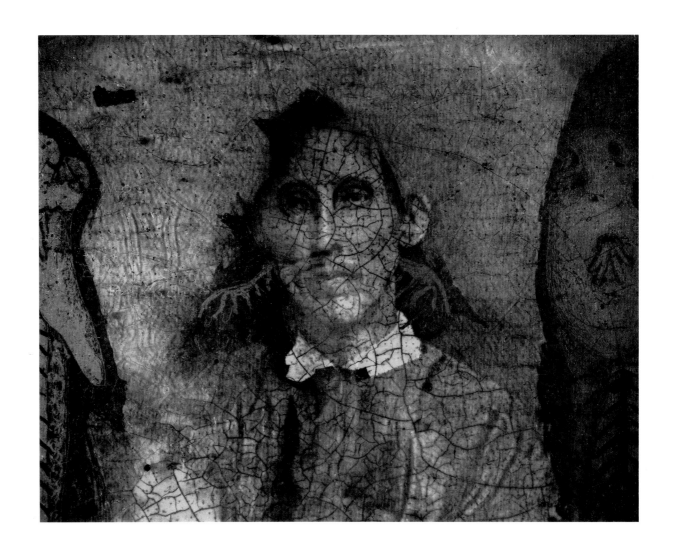

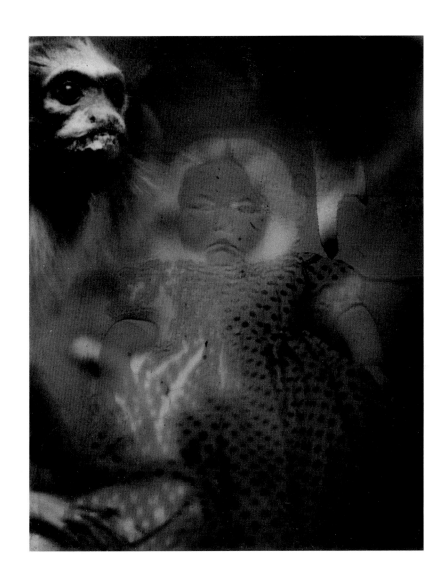

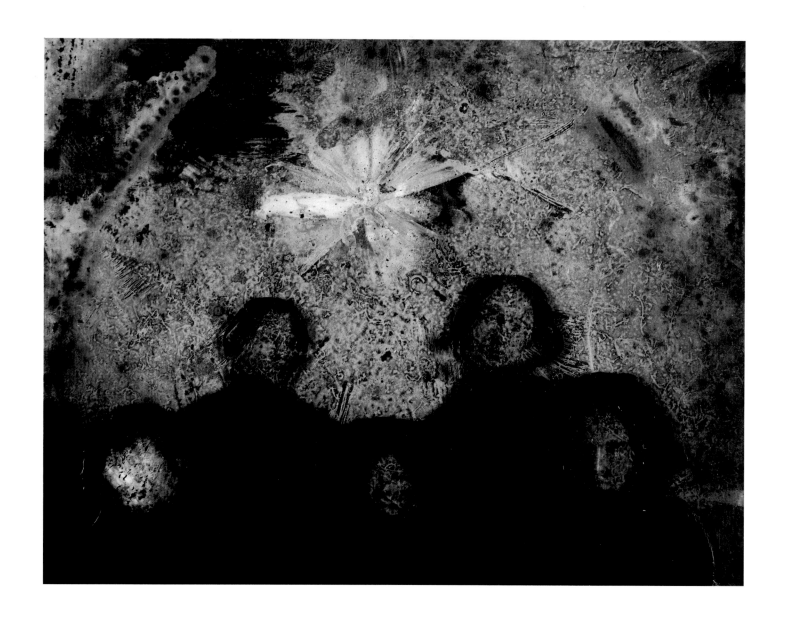

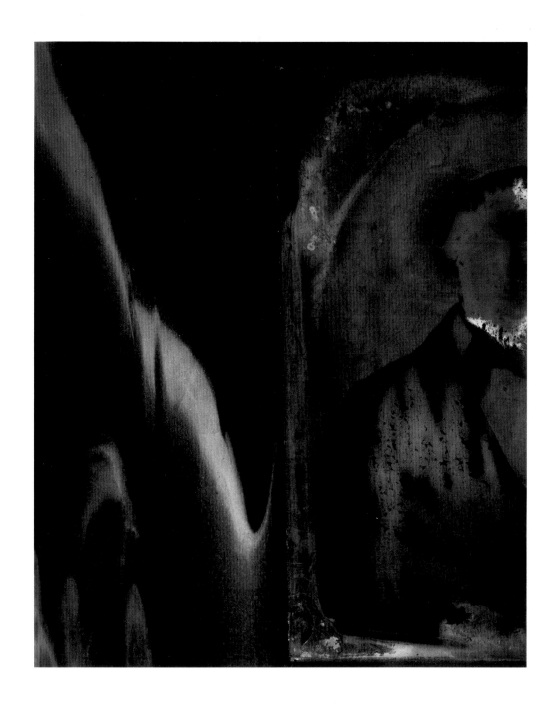

The Exquisite Corpse

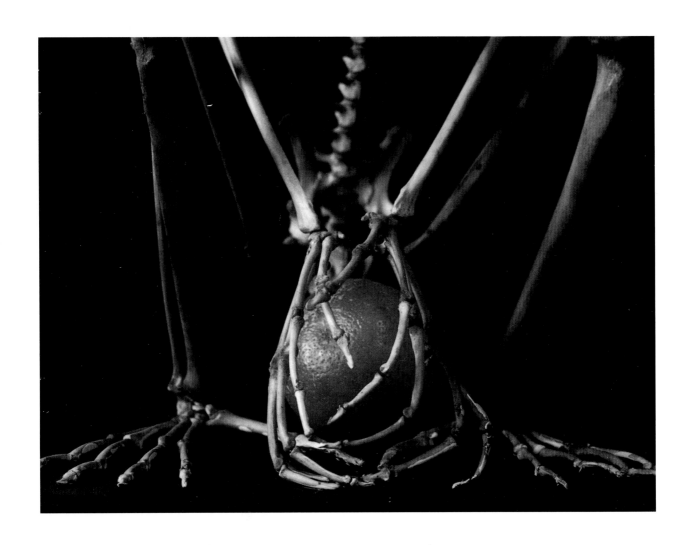

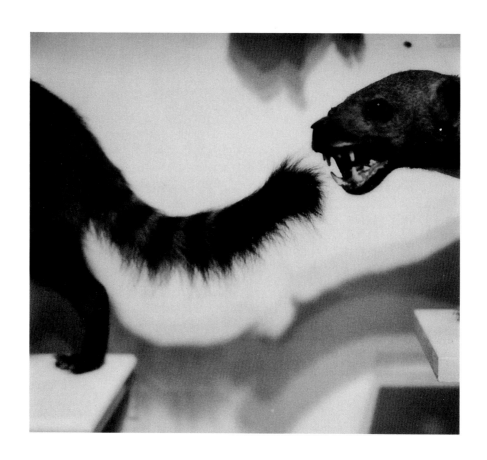

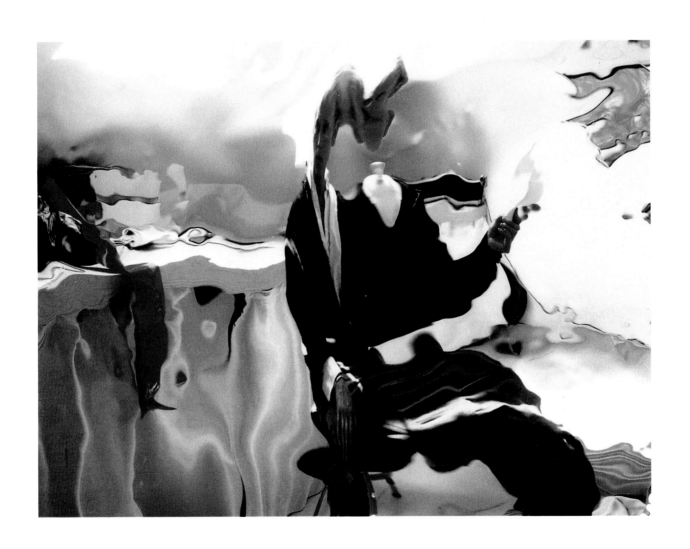

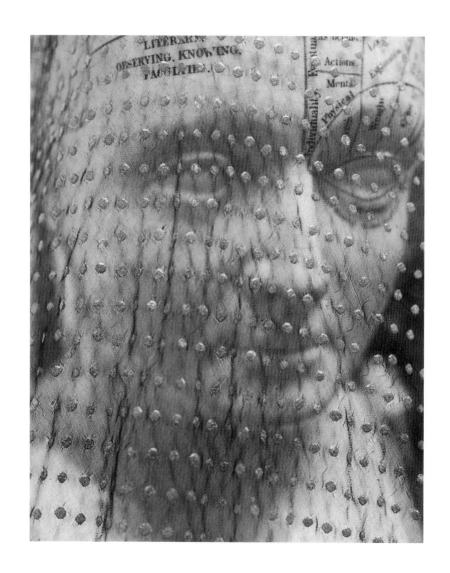

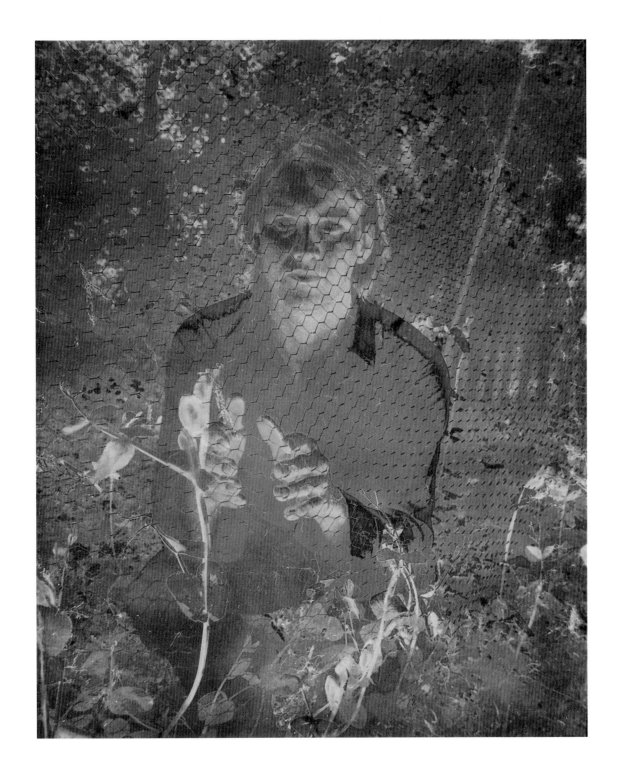

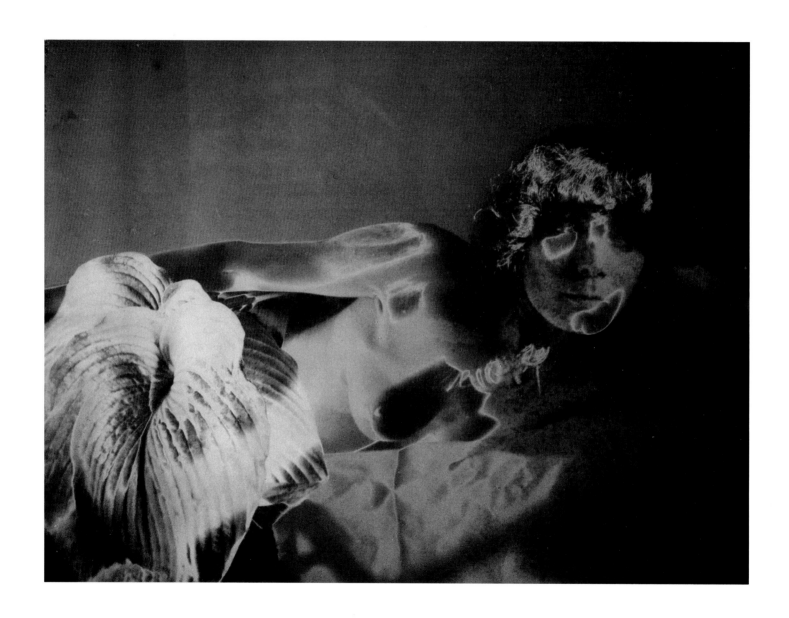

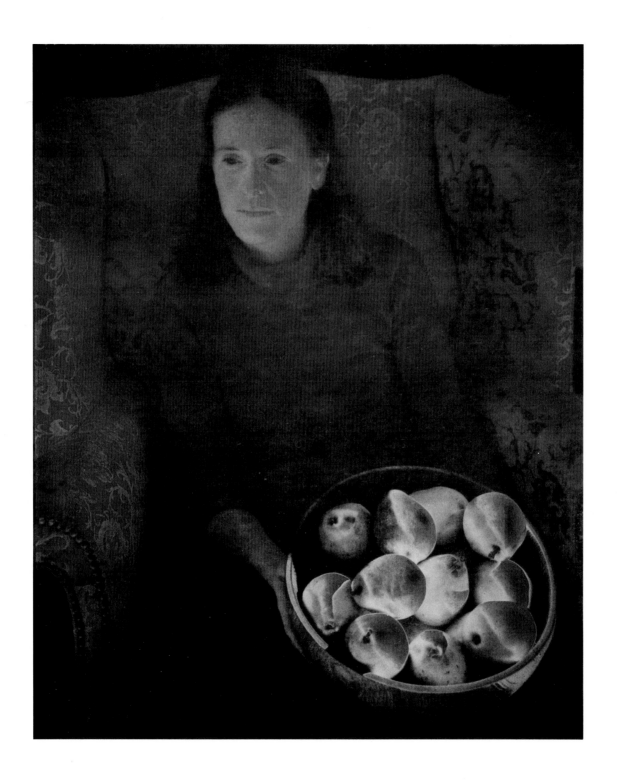

O.P. with Pears • 18

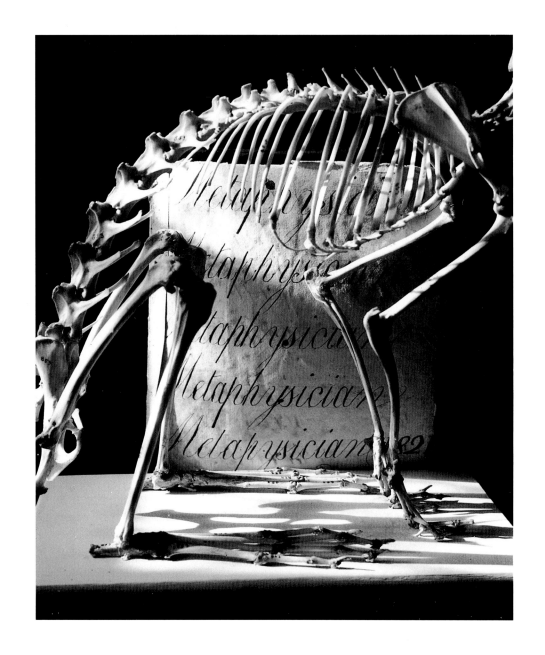

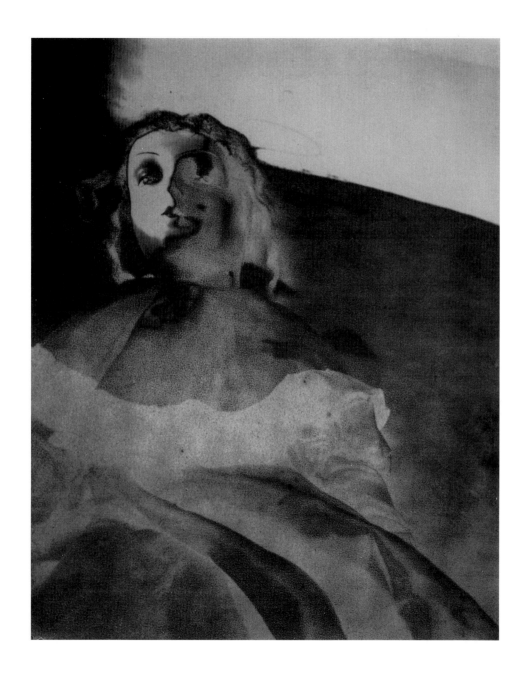

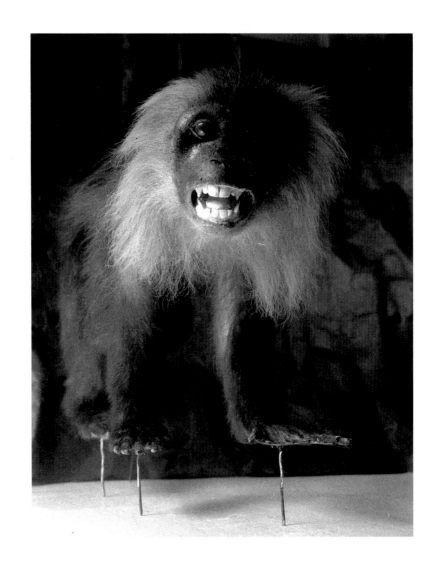

21 • *Fakir*

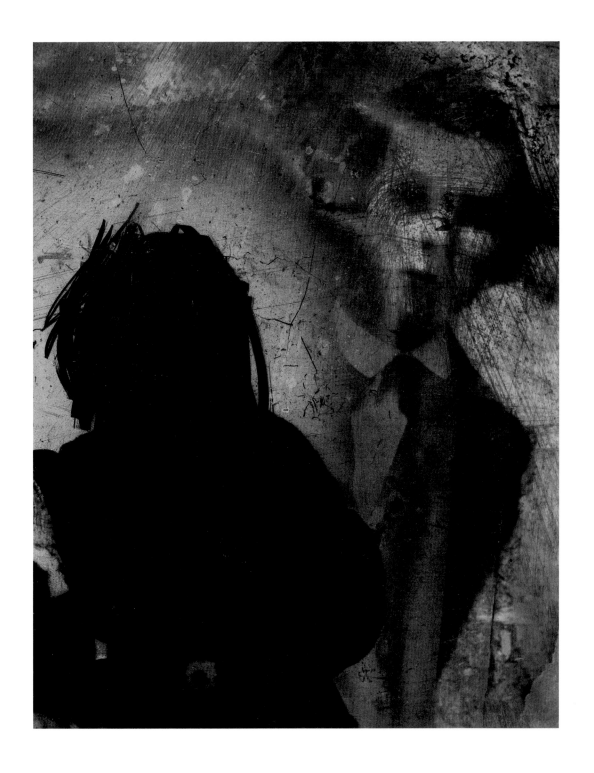

Crossing Over

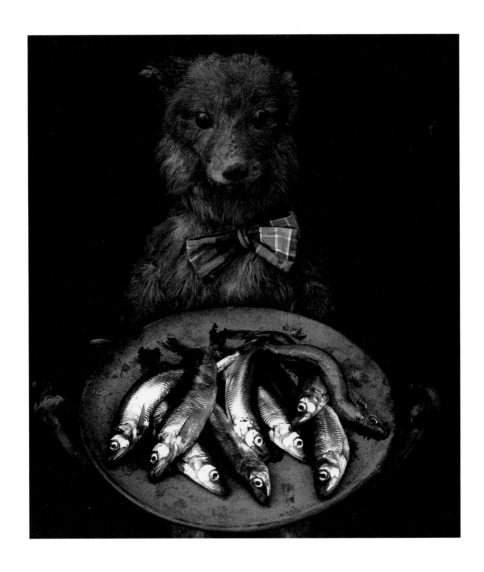

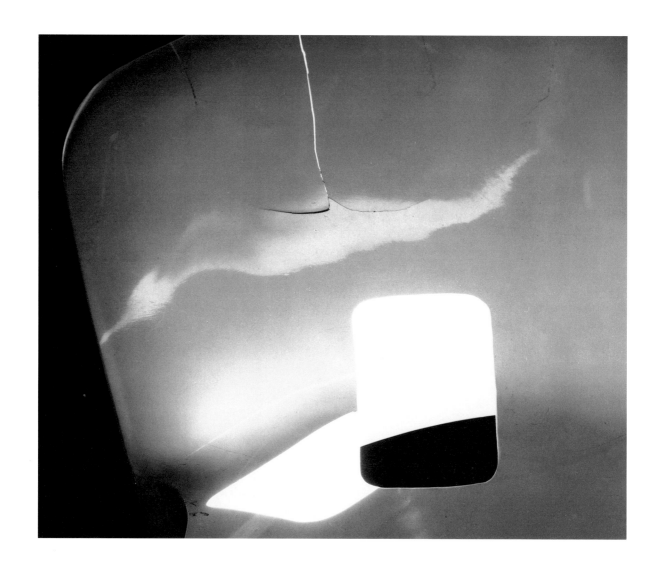

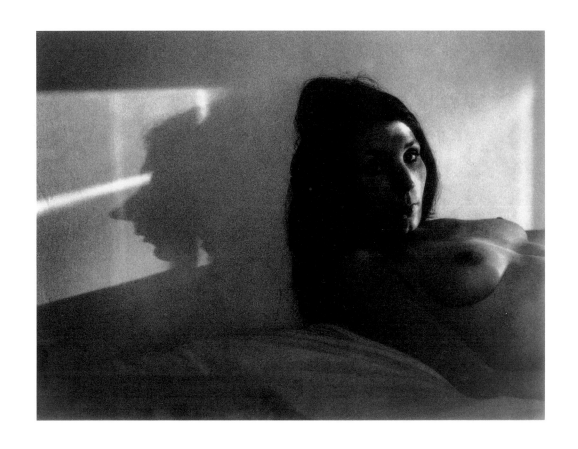

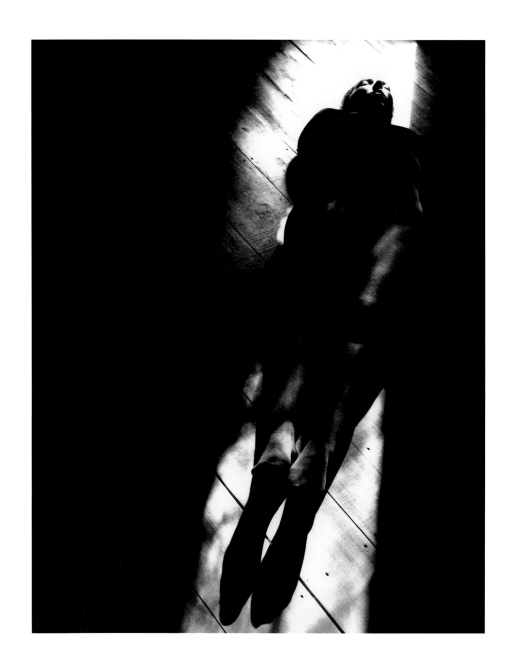

26 • *Shot from Guns*

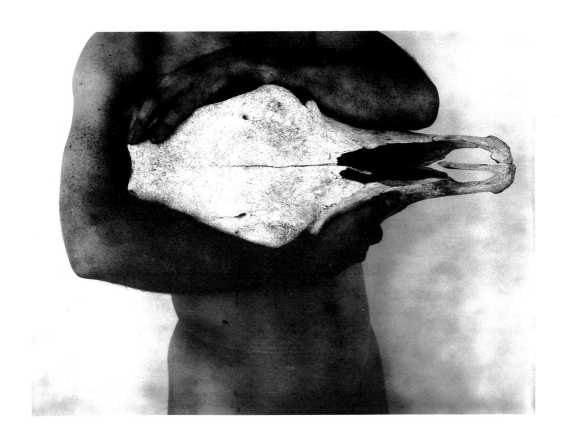

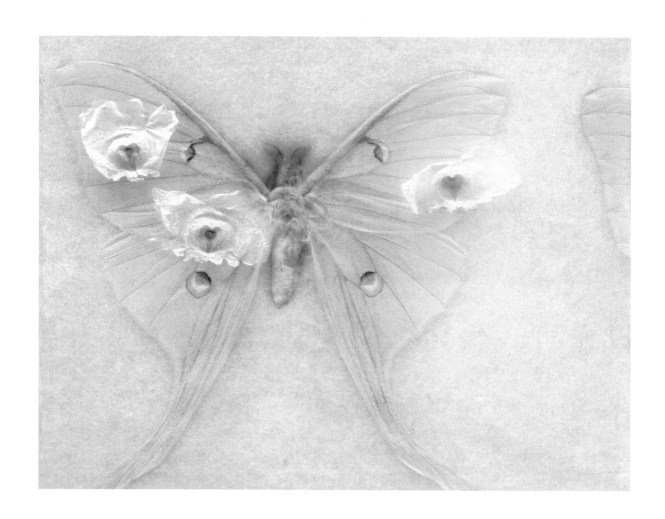

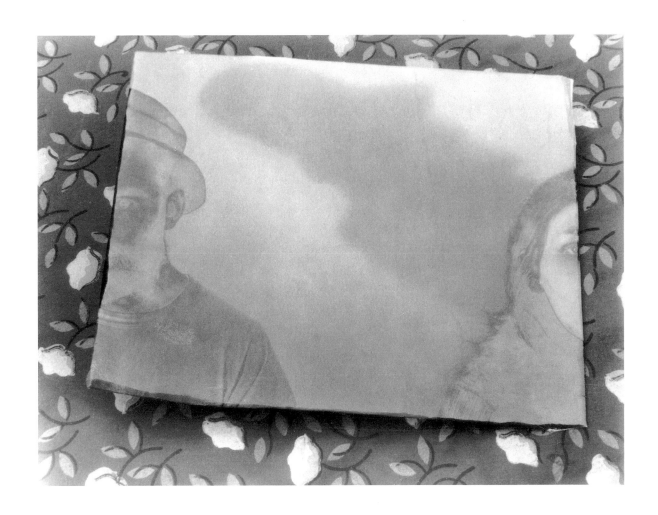

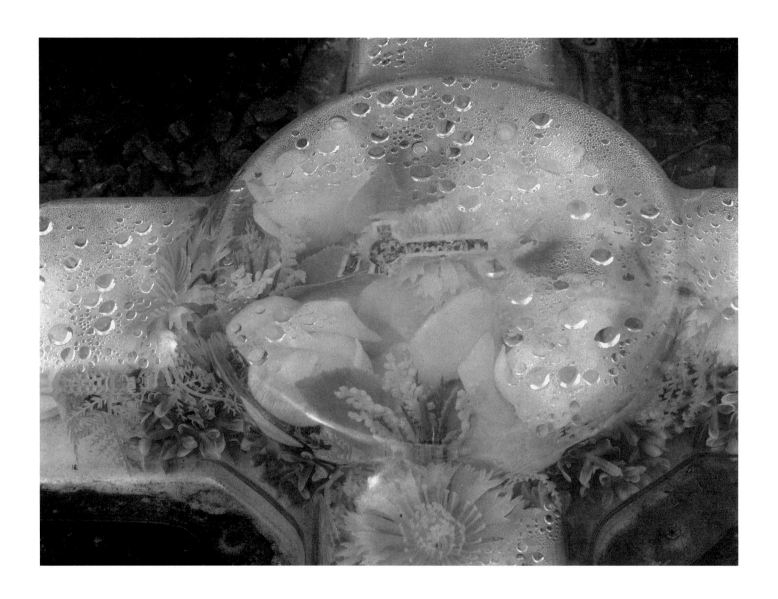

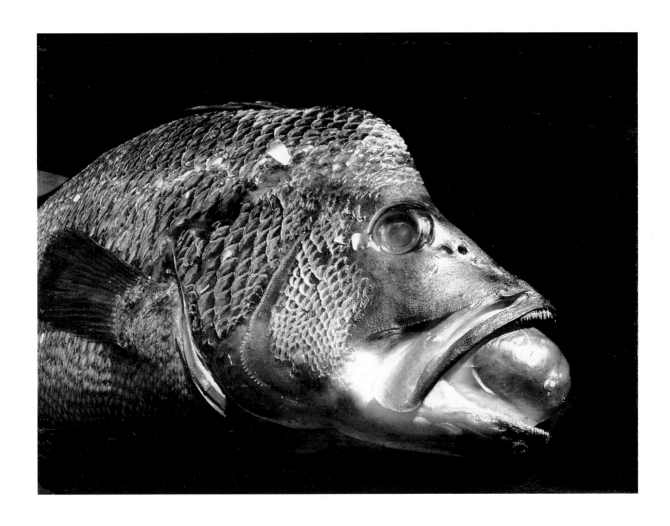

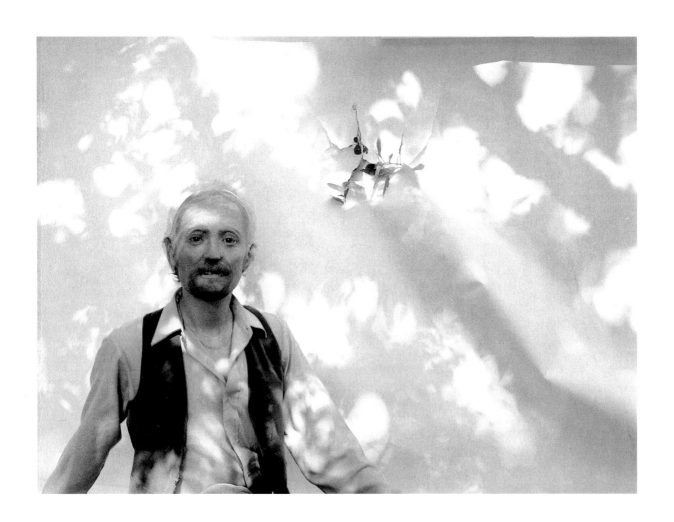

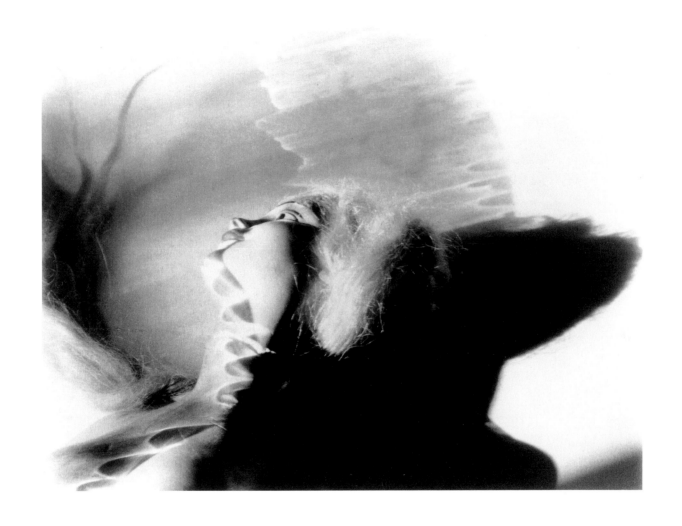

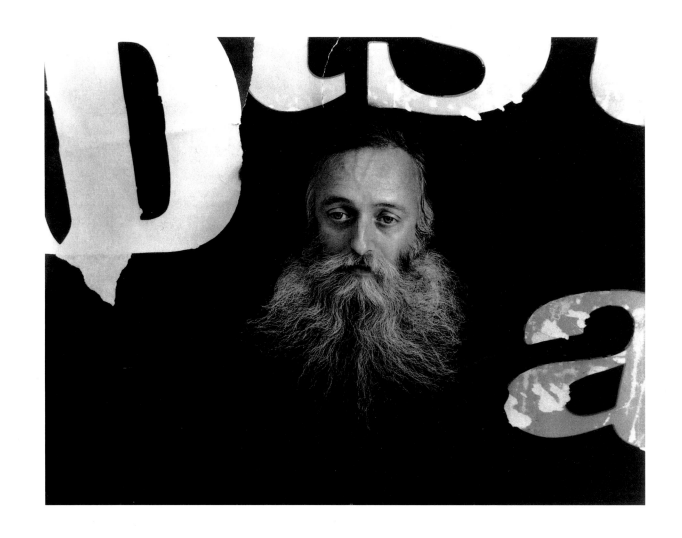

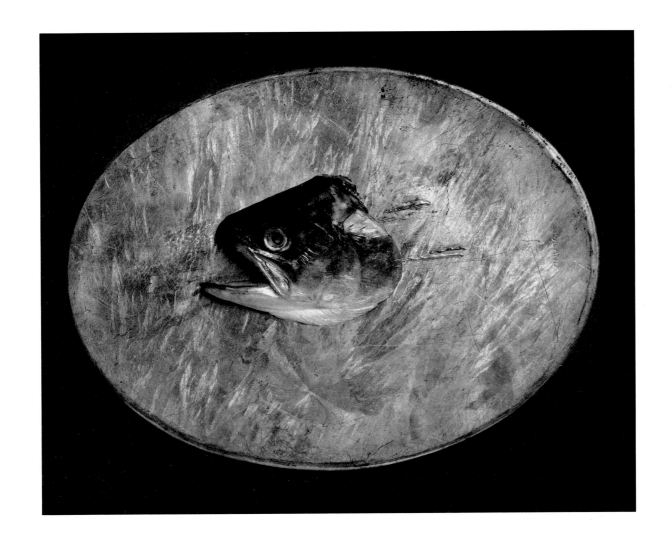

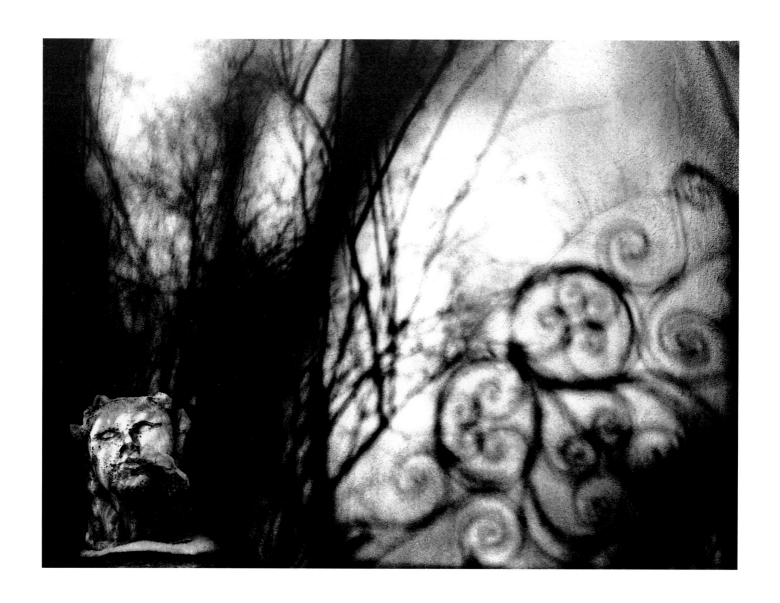

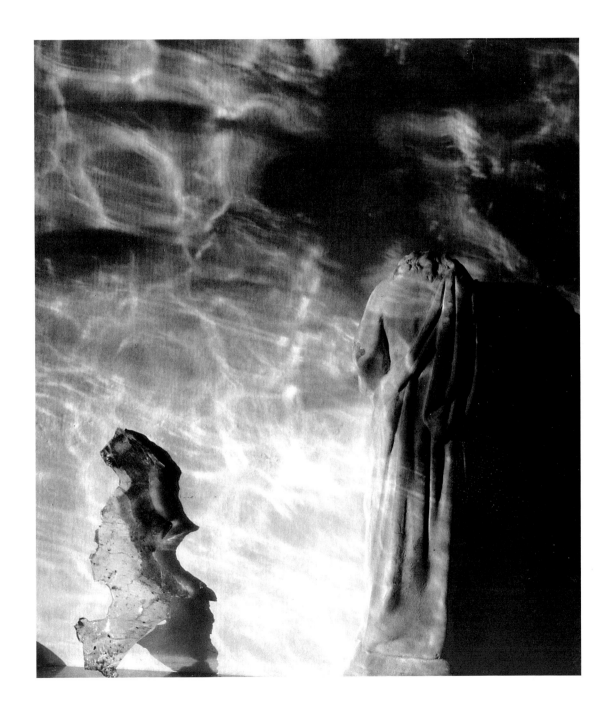

R. E. M.

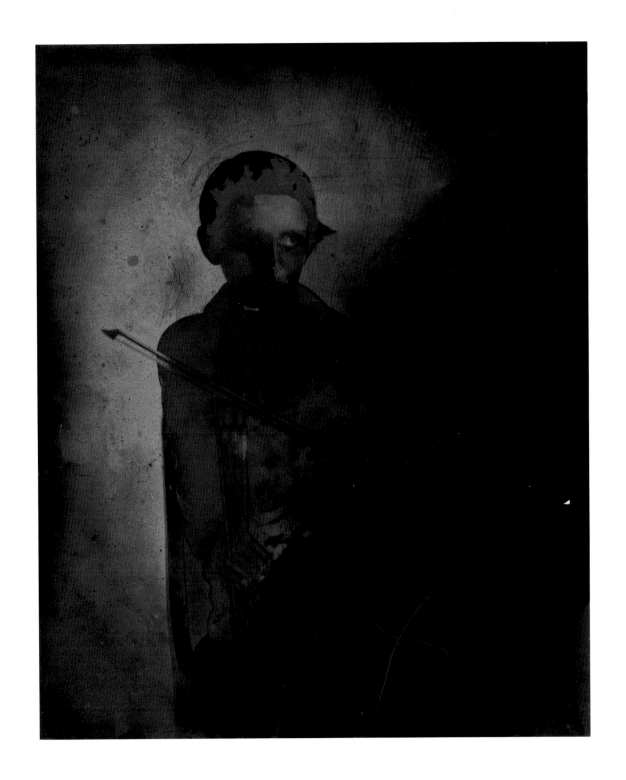

Boy with Violin • 38

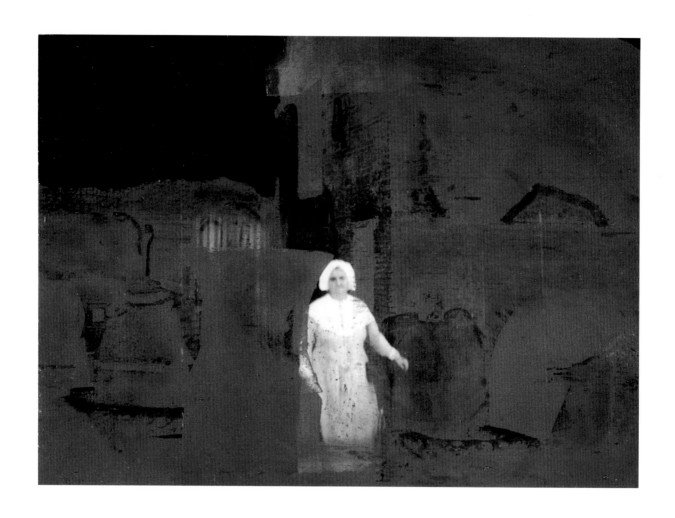

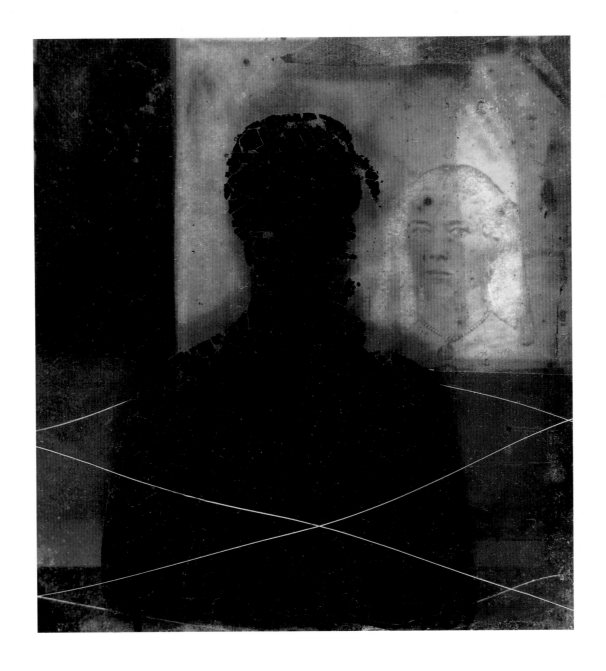

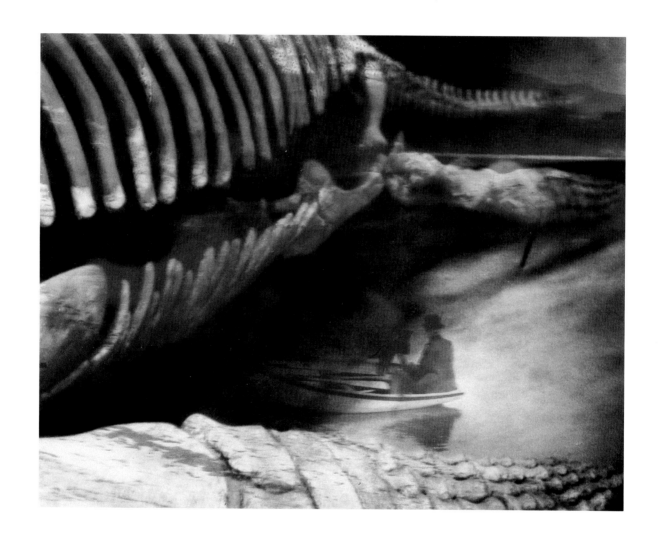

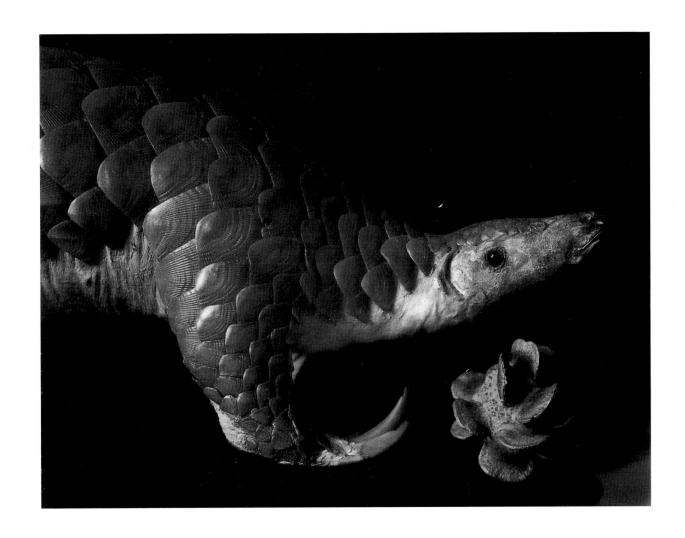

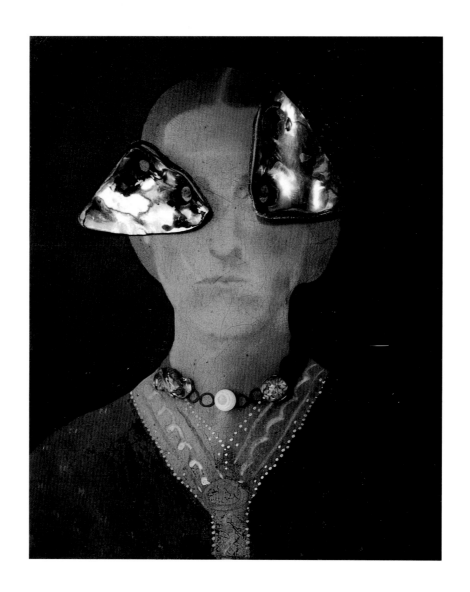

43 • Iris

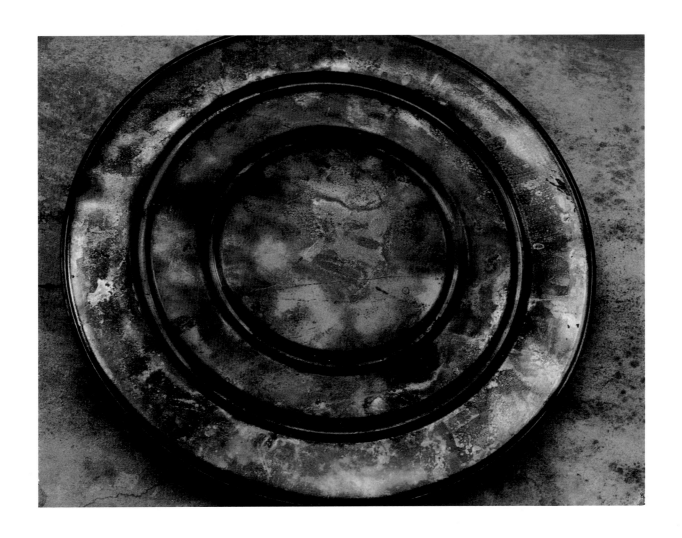

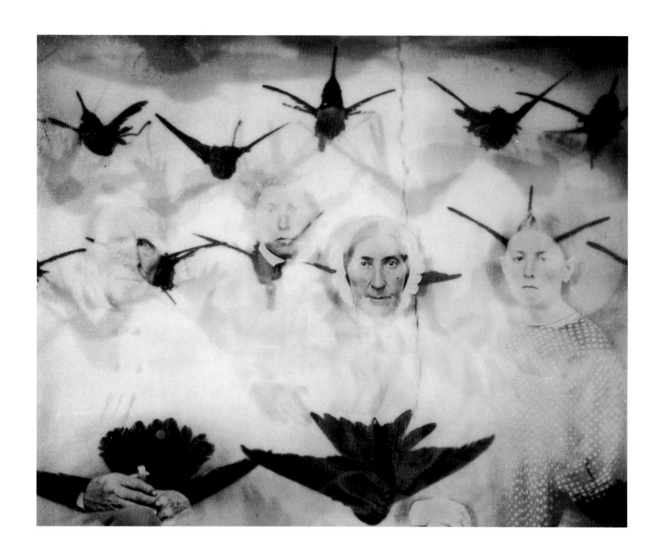

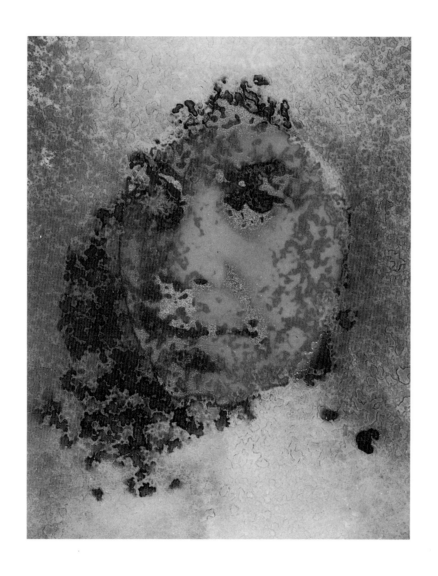

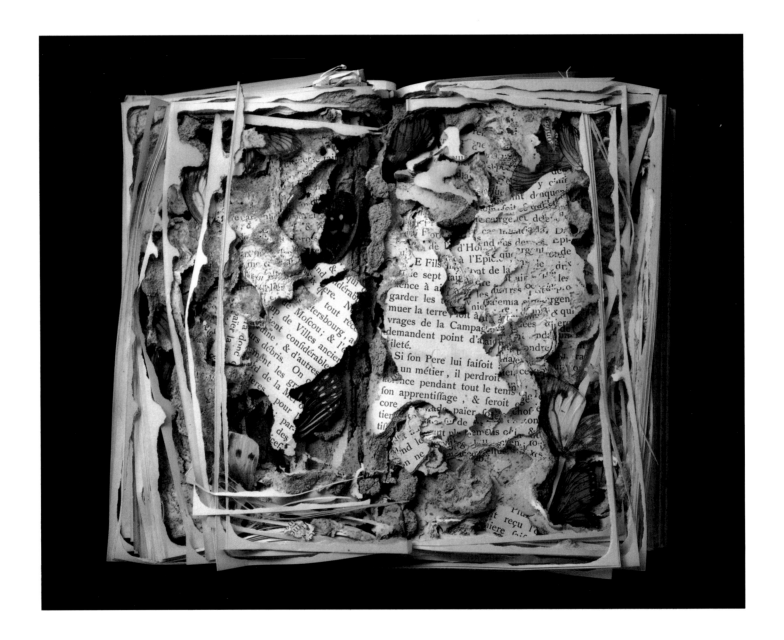

47 · *Untitled*

HALF-LIFE
was designed by Dennis William Purcell and Kathleen Riley.
It was composed in VIP Syntax and Snell Roundhand by Typographic House.
Acme Printing Company prepared the separations and printed the book
on Warren's Cameo Dull, and it was bound by Robert Burlen & Son.